Life & Love

A Book of Embraces

BY THE
EDITORS
OF

With an introduction by
Garrison Keillor

Little, Brown and Company
Boston New York Toronto London

First Edition

Library of Congress Cataloging-in-Publication Data

Life & love : a book of embraces / by the editors of Life ; with an
 introduction by Garrison Keillor.—1st ed.

 p. cm.

 ISBN 0-316-52645-2
 1. Interpersonal relations–Pictorial works. 2. Love–Pictorial
 works. 3. Friendship–Pictorial works I. Life (Chicago, Ill.: 1978)
 II. Title: Life and love.
 HM132.L53 1995
 306.7'022'2–dc20 94-32392

10 9 8 7 6 5 4 3 2 1
RRD-OH

Published simultaneously in Canada by
Little, Brown & Company (Canada) Limited
Printed in the United States of America

PROJECT EDITOR: Melissa G. Stanton
PICTURE EDITOR: Debra Cohen
DESIGNER: Carol March

PICTURE SOURCES:
Agence-Vandystadt: Richard Martin;
Associated Press: Dennis Cook;
Contact Press Images: Frank Fournier;
Impact Visuals: Dan Habib;
LGI: Lynn Goldsmith;
Library of Congress, Prints and Photographs Division,
Toni Frissell Collection;
Little Bear Inc.: Bruce Weber;
Magnum Photos: Ian Berry, Elliott Erwitt (3), Burt Glinn,
Philip Jones Griffiths, Eli Reed, Eugene Richards (2), Larry Towell;
Pressen Bild/Photoreporters: Jan Du Sing;
Sipa: Tom Haley; Sygma: J.P. Laffont;
Woodfin Camp and Associates: Ken Heyman (2).

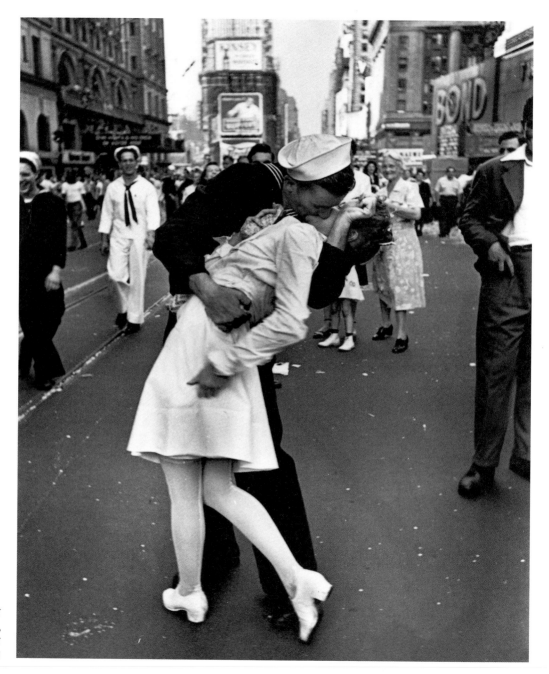

V-J DAY
TIMES SQUARE,
NEW YORK CITY
Alfred Eisenstaedt, 1945

I saw the famous Eisenstaedt picture of the V-J Day kiss in LIFE when I was a boy and thought it was sweet: the girl in the white dress standing, bent back in the arms of the sailor who is planting a hard kiss on her lips, with Times Square and grinning onlookers in the background. And now, in another era, one can look at it and imagine an act of harassment. It is only an embrace, but the woman's body looks stiff, as if this kiss is not her idea and she can't muster up enthusiasm for it; she isn't clinging to the sailor, she's just hoping he doesn't drop her on the pavement. The picture illustrates the great danger and achievement of an embrace—to be any good, an embrace must be mutual, and there may be a chasm of uncertainty between the impulse and the deed, even when you hug your wife. Maybe she is still mad from when you came home an hour late 10 minutes ago. You hug her and she says, "What's that supposed to mean?" All an embrace means is that you expect to find the one you reach for reaching for you.

My mother told me that on V-J Day, when news came that the war was over, people were so overjoyed they dashed into the streets and hugged complete strangers, even in Minneapolis, where we lived. The thought of that surprised me then and still does. People in the Midwest don't hug that much unless they're Italian. Even in a euphoric moment, swamped by emotion, a true midwesterner would be careful whom he threw his arms around. To us, an embrace is too intimate to be conferred on mere acquaintances; it would feel insincere. In the show business, which I hang out on the periphery of, there are people who embrace anybody they've ever been introduced to. This seems almost as unnatural to me as eating off the floor. I have met people who, as a result of a seminar they attended once, say to me, "I'd like to give you a hug if that's all right," which strikes me as odd. A hug that has to be negotiated? The huggee-to-be is trapped: You can't decline, and it's too late to put up a sign, *Thank You For Not Hugging*.

To a shy midwesterner, an embrace is a profound and delicate statement, even the ordinary friendly hug you might give your dog, or your dad. It is never perfunctory, always full of feeling. The little girl embracing the elephant in this book must feel the immensity of the moment, and so do I, always, and always have approached it warily. Sitting next to a girl on the school bus, you put your right arm across the back of the seat behind her, testing her—does she glance back in disgust, as if she thought it was a snake? No? Then you put your right hand onto her shoulder, a tentative embrace, a deniable one, and you lean slightly against her and smell her fragrance. You like this girl a lot. She is so memorable and exciting, you would love to put both arms around her. Maybe she wants you to. *You* want you to. But what would it mean? Would it mean only that you are fond of her at this sunny moment, which is the truth, or would she think it meant The First Step On The Road To *Ba-dum Ba-dum Ba-dum*? A great romantic, as I was when I was 16, adores the distant, unattainable love—for me, that was Audrey Hepburn—but then I needed to find someone to go to the dance with, and that was the girl whom I sat next to on the bus, who was stocky, had a flat nose and mousy hair, and was attainable. She towed me onto the gym floor, and we assumed the waltz position, with my left hand on her right hipbone, her left hand in my right hand, her right hand on my left shoulder, and the air full of saxophones. We danced a long time together because nobody else wanted to dance with either of us, and it was pleasant talking to her with her head against my shoulder and my cheek against her hair. I loved having her ear just below my mouth and to be in her arms, to sway, to feel her hand on my shoulder, to hold her hand, and to feel her hipbone move. Maybe her hair was mousy, but at such short range, it didn't matter. I kissed her eyebrow and we went out in the 1958 moonlight and sat on the grass and necked with great tenderness and curiosity.

❧ I kissed her and was surprised how easy this was. So I did it again. I stroked her cheek and touched her hair. I touched my lips to her hair, I kissed her neck, I ran my finger along her hairline and down her neck to her collarbone, I put my arms around her and we lay on the grass facing each other, and it was lovely, right up until the moment I had to remind myself that this was The Road That Leads Over The Cliffs Of Desire And Onto The Rocks Of Regret, and to hold my horses, or else in five minutes we'd be high school dropouts living in her parents' basement with our tiny child named Melody and I'd be pumping gas at the Pure Oil station. ❧ It surprised me how naturally it all came to us: holding hands, caressing, nuzzling, fondling, snuggling, the little ballet of affection, even kissing, which I had worried I might not be good at—how there was no awkwardness, no comedy, no falseness, and how, in this language of touching, you can easily find what it is you really want to say. ❧ Sex is glorious and earthshaking, as well as necessary, but it is in touching each other, holding each other's hands, stroking the skin, that we are most eloquent. So many different ways to make a nest of our bodies and put skin against skin. We humans can be awfully formidable, with our intelligence jingling at our side and our ambition grinding away and our high standards fluttering in the breeze, and it is thrilling when someone slips through the defenses and puts an arm around us. Sex is an athletic act, like bowling except without the shirt, and like bowling it can sometimes be (yes, it can be) boring, but the small, sweet gesture of an arm slipped around your waist somehow never loses its poignancy and surprise. Here we stand, old friend, side by side in a reflective moment, a great swath of silent history between us, and perhaps it is a bilateral inspiration, or perhaps you think of it a half second before I do—somehow we embrace and are embraced. You move me, and I care for you, and there is simply no other way to say so. **GARRISON KEILLOR**

Life
&
Love

A
Book
of
Embraces

CALIFORNIA
Elliott Erwitt, 1955

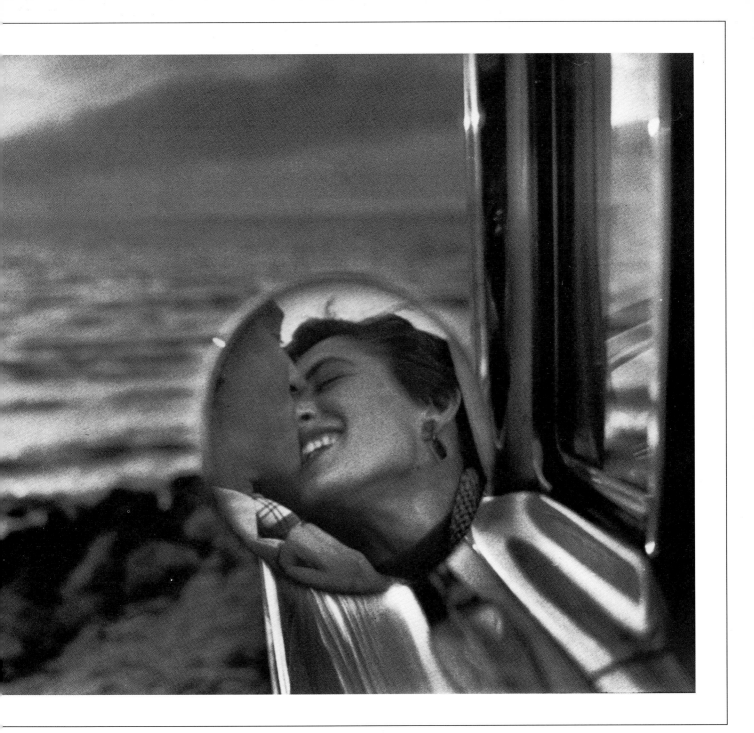

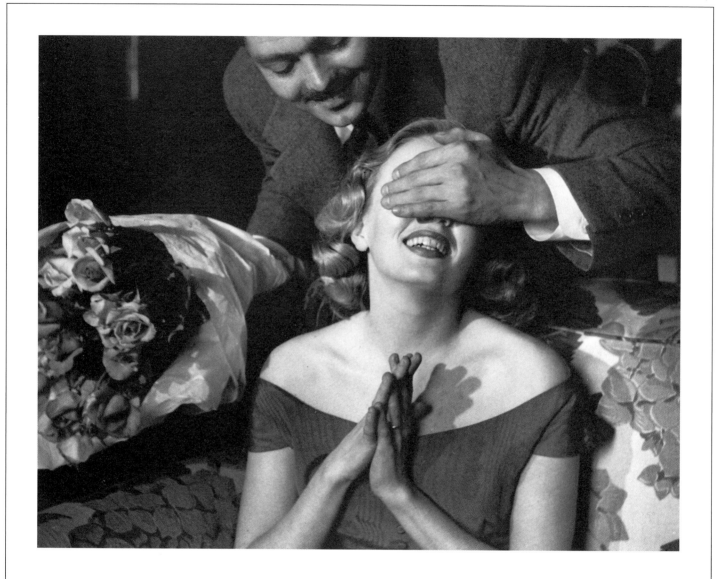

GUESS WHO
Nina Leen, 1948

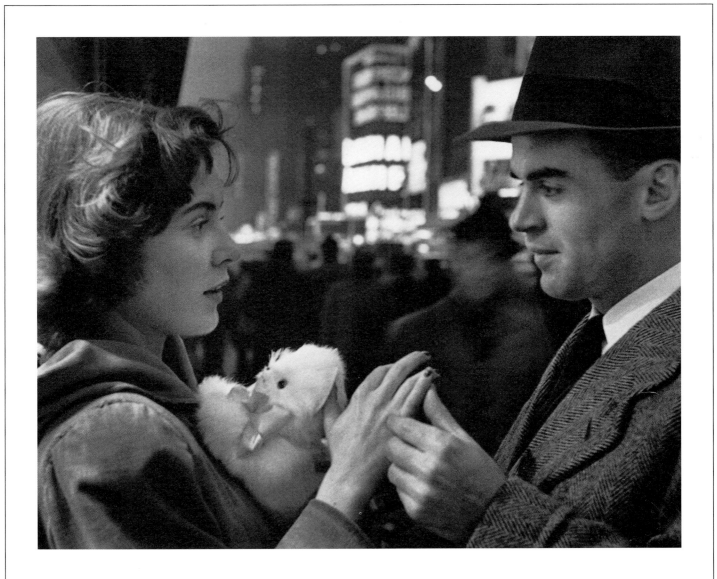

GWYNED AND DATE
Leonard McCombe, 1948

AT THE MOVIES
Burt Glinn, 1961

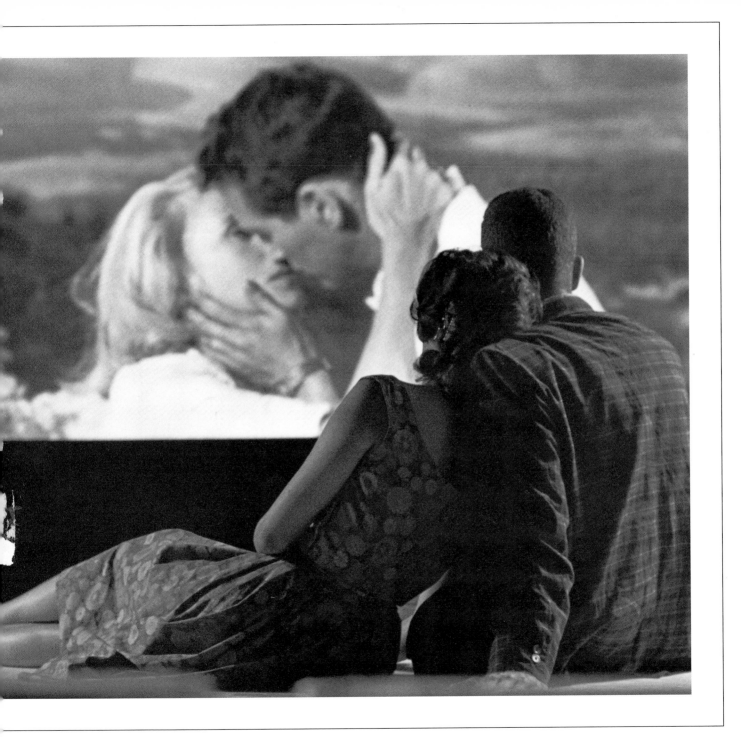

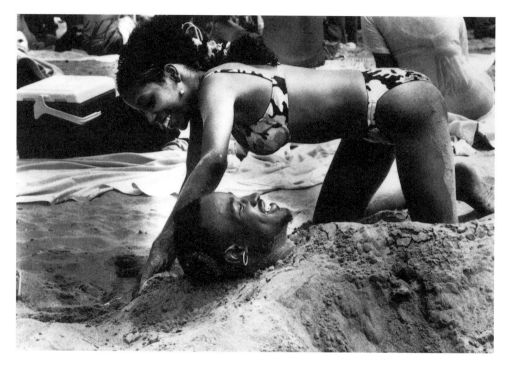

BURIED TREASURE
Donna Ferrato, 1992

<div align="right">

ZUMA BEACH, CALIFORNIA
Lynn Goldsmith, 1992

</div>

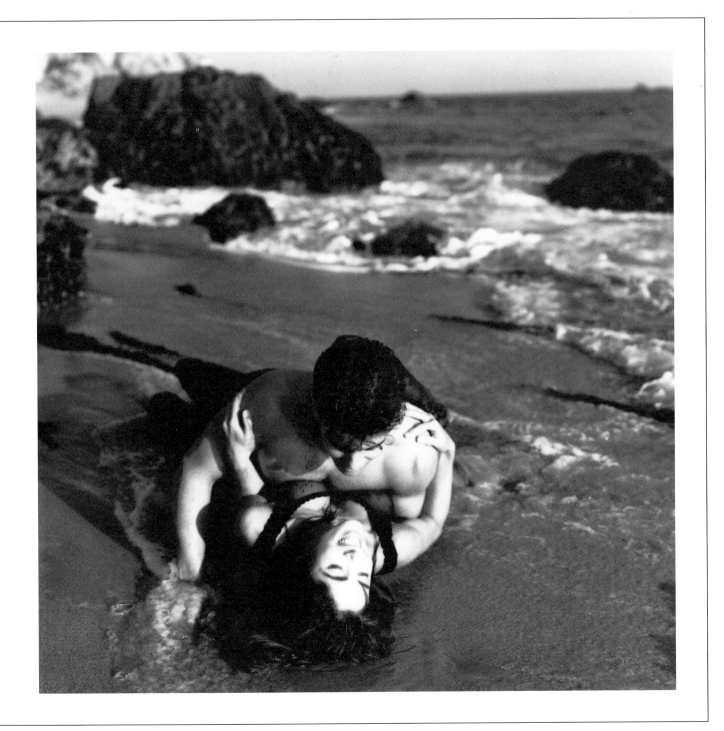

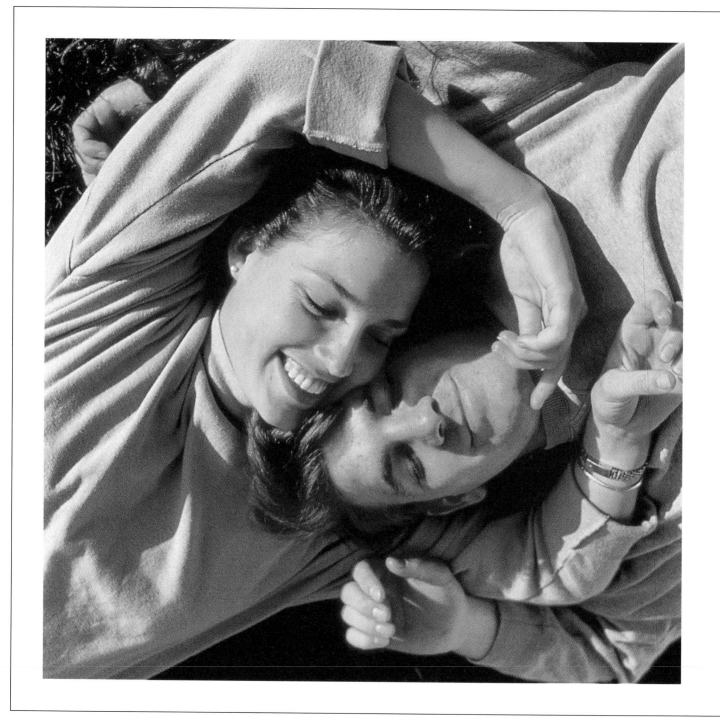

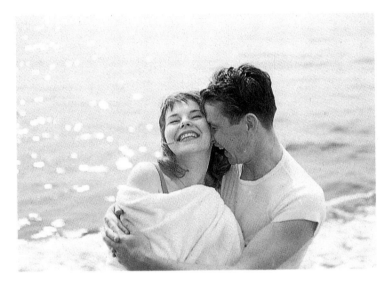

AT THE BEACH
Howell Conant, 1959

ALICIA AND BUDDY
Jeanne Strongin, 1990

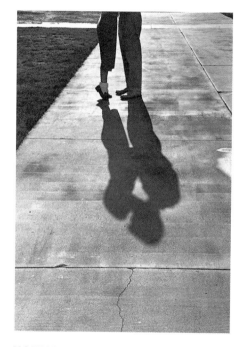

YOUNG LOVE
Carl Iwasaki, 1961

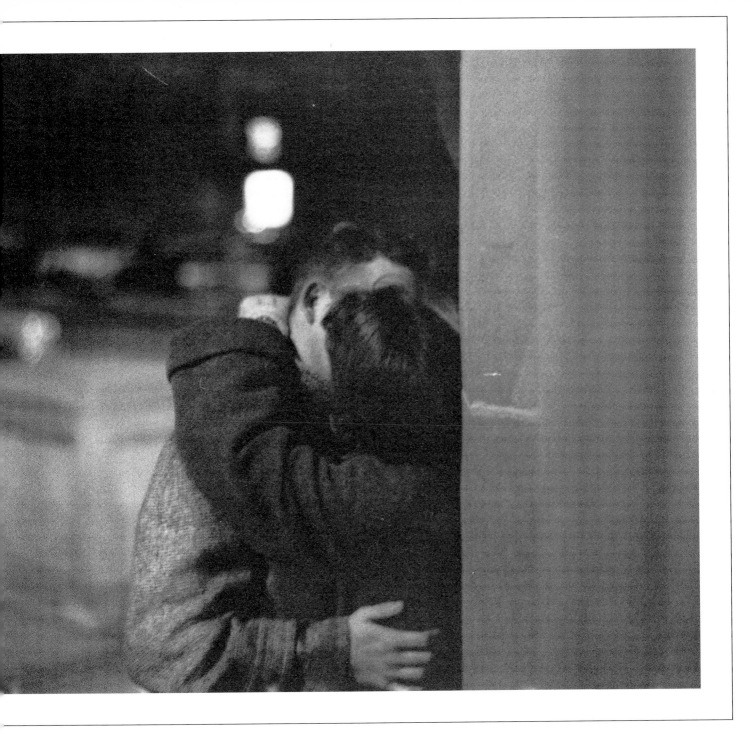

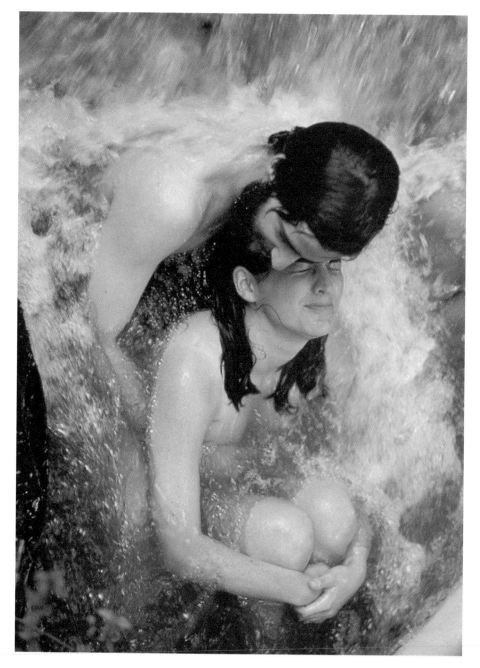

WOODSTOCK
Bill Eppridge, 1969

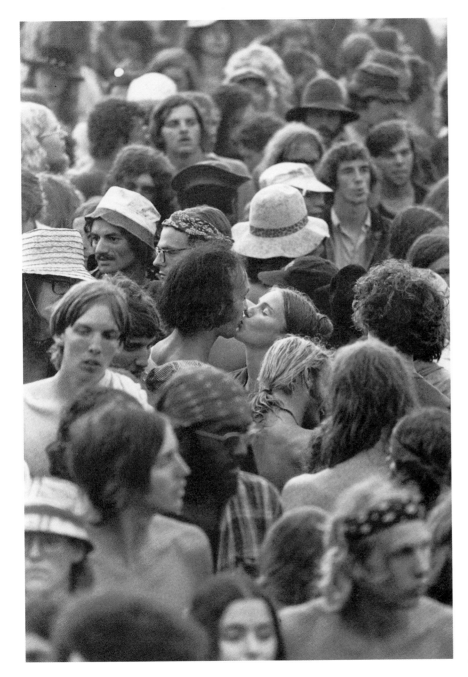

CONCERT AT WATKINS GLEN
J.P. Laffont, 1973

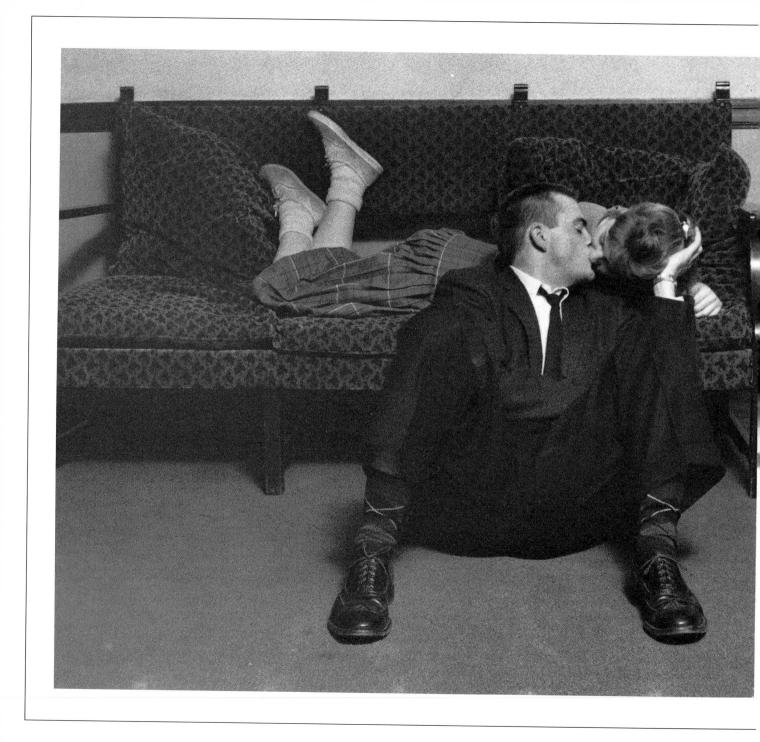

LOVE SEAT
Grey Villet, 1957

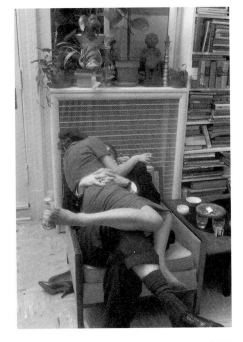

COCKTAIL PARTY
Francis Miller, 1957

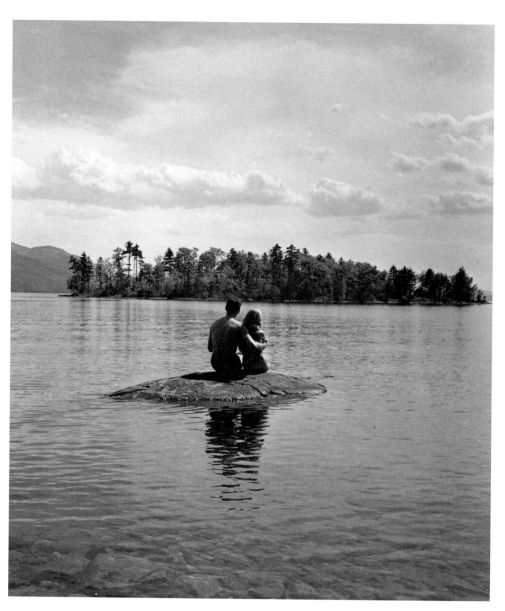

PRIVATE ISLAND
Nina Leen, 1941

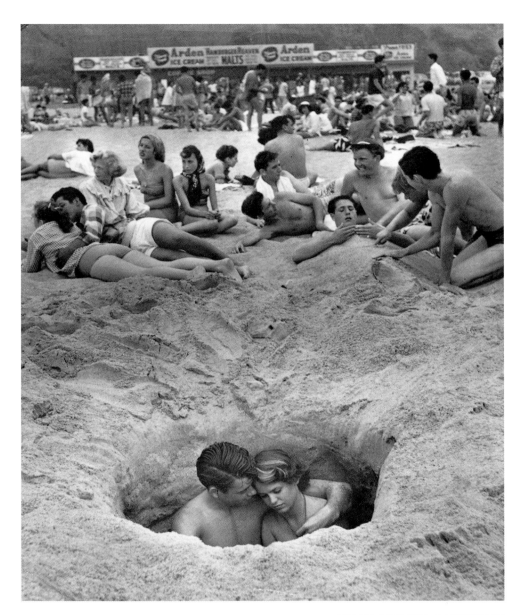

SANTA MONICA, CALIFORNIA
Ralph Crane, 1950

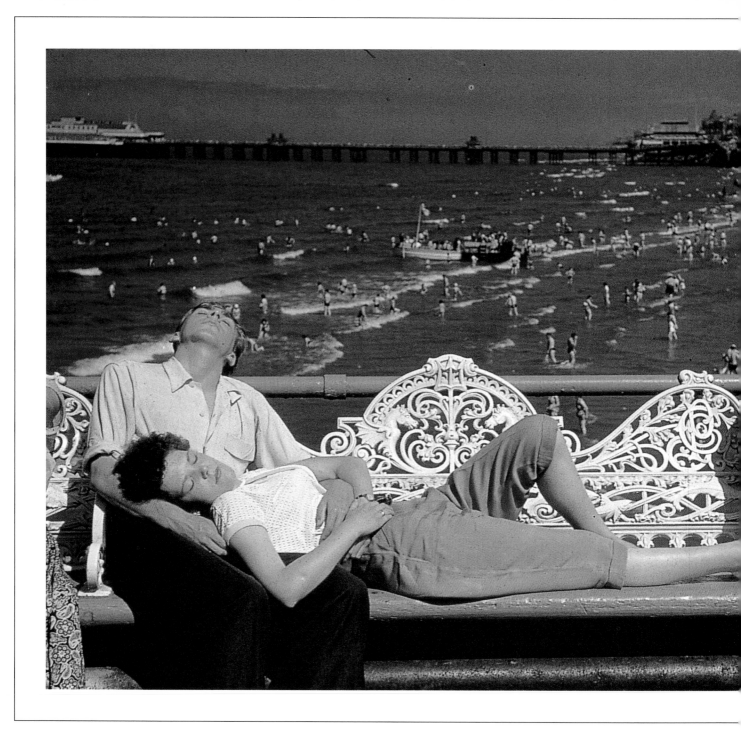

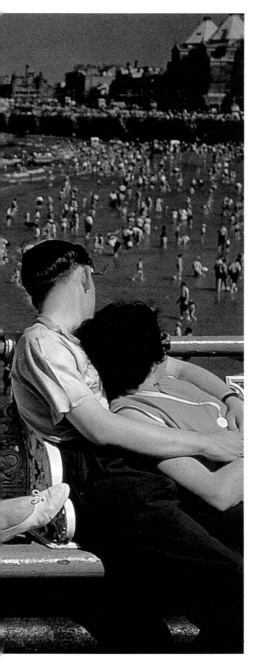

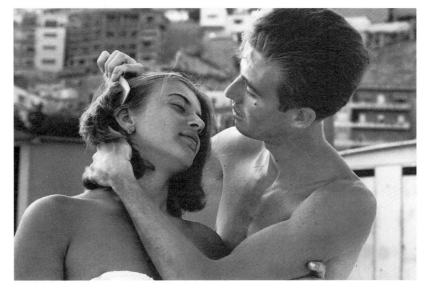

ITALY
Paul Schutzer, 1963

BLACKPOOL, ENGLAND
Leonard McCombe, 1955

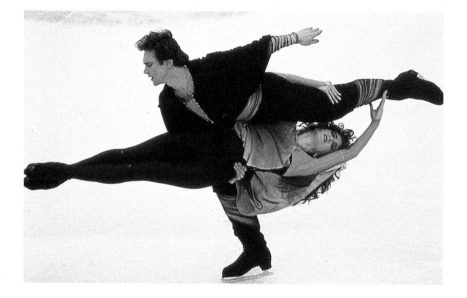

A GOLD MEDAL EMBRACE
SERGEI PONOMARENKO AND
MARINA KLIMOVA
Richard Martin, 1992

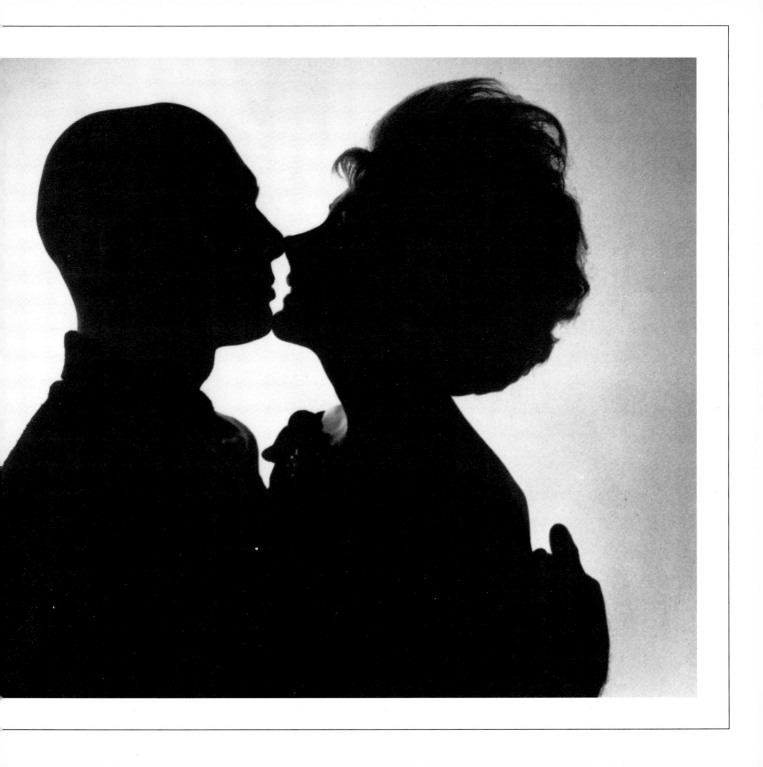

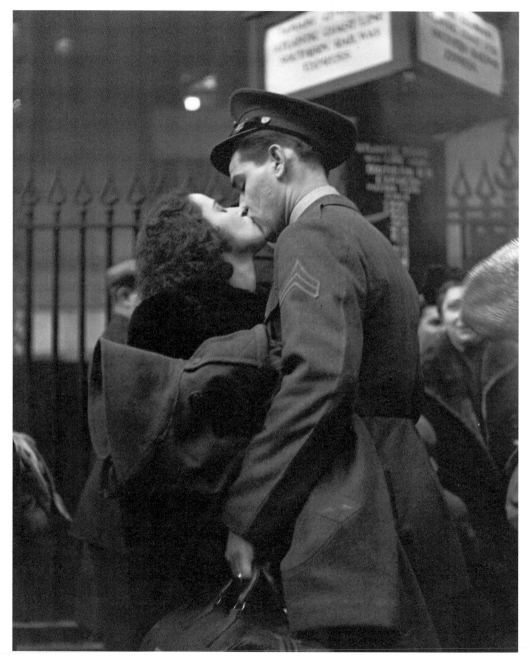

PENN STATION
FAREWELL
New York City
Alfred Eisenstaedt, 1943

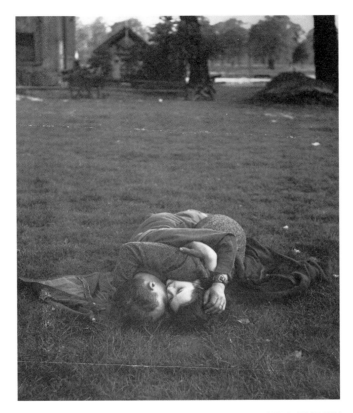

HYDE PARK, LONDON
Ralph Morse, 1944

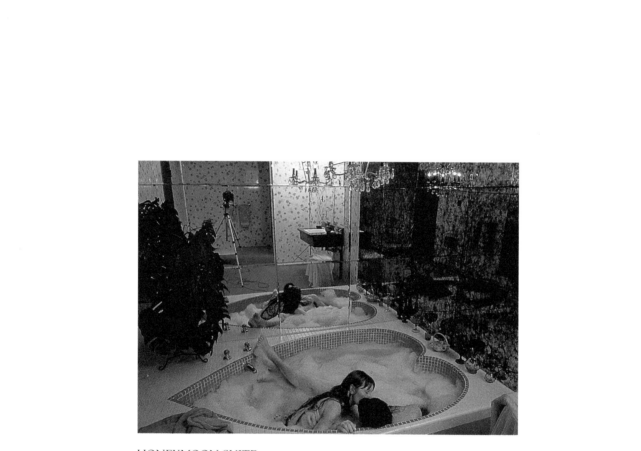

HONEYMOON SUITE
George Silk, 1971

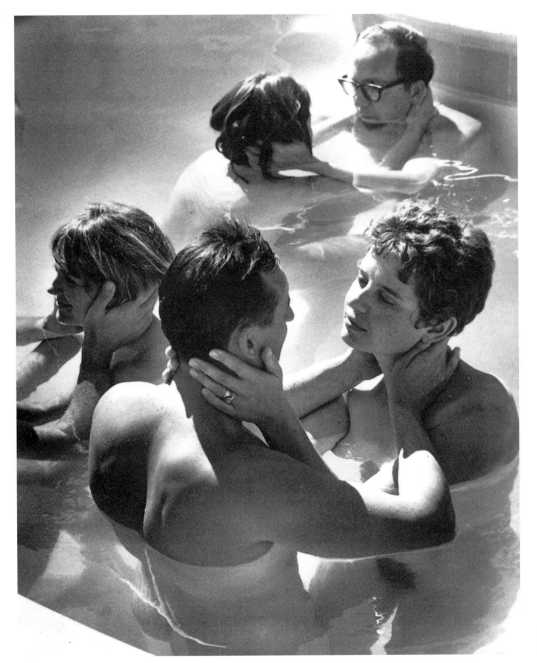

ENCOUNTER GROUP
Ralph Crane, 1968

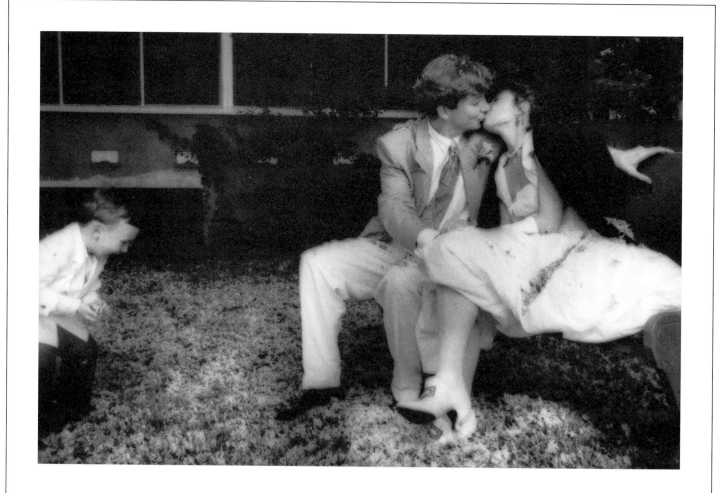

GAIL AND STEPHEN'S WEDDING
Elizabeth Zeschin, 1990

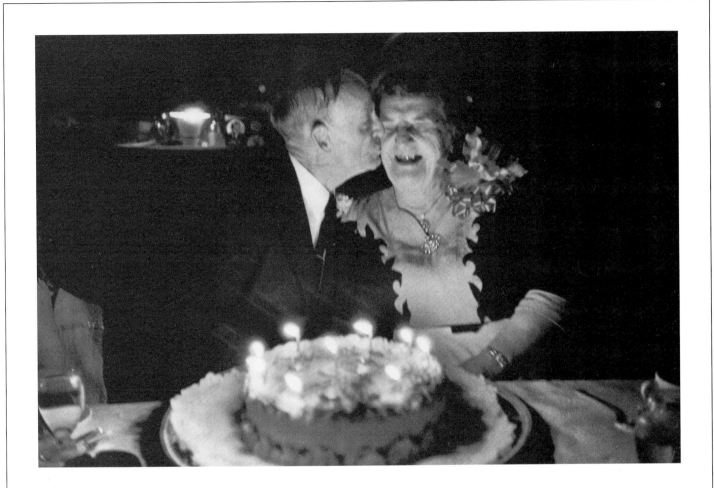

SIXTIETH WEDDING ANNIVERSARY
Elliott Erwitt, 1955

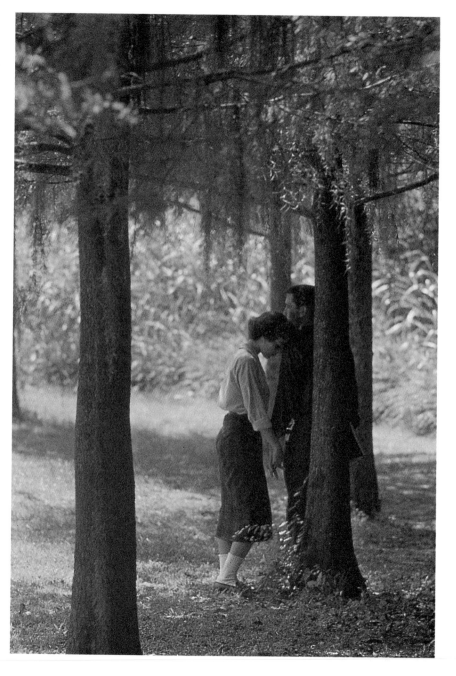

A WALK IN THE WOODS
George Silk, 1959

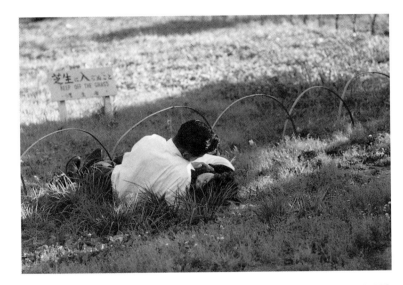

HIBIYA PARK, TOKYO
Margaret Bourke-White, 1952

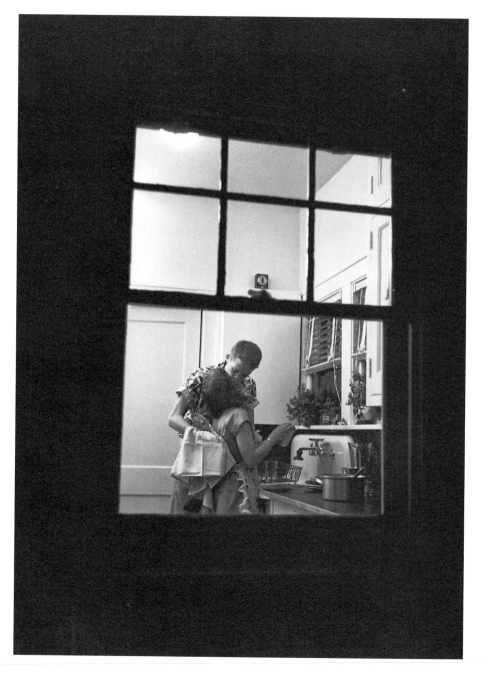

DOING DISHES
Carl Iwasaki, 1954

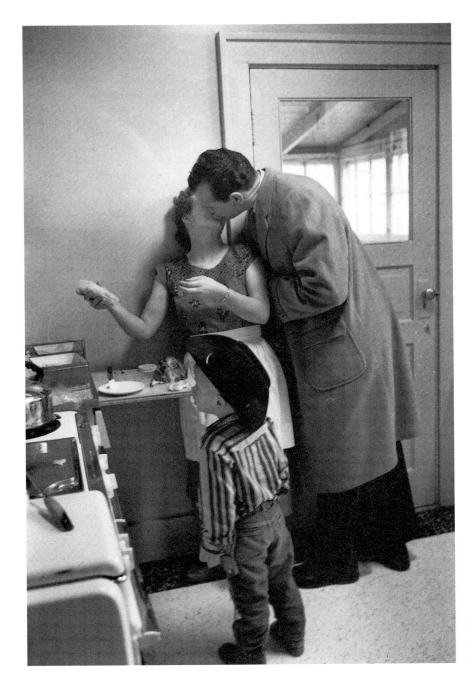

GOODBYE KISS
Carl Iwasaki, 1958

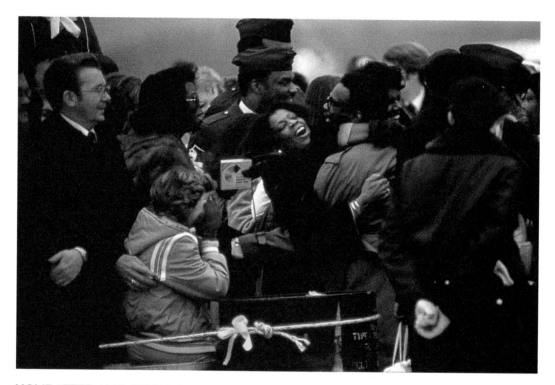

HOME AFTER 444 DAYS HELD
HOSTAGE IN IRAN
Bryce Flynn, 1981

WELCOME HOME, SAILOR
Press Association, Ltd., 1966

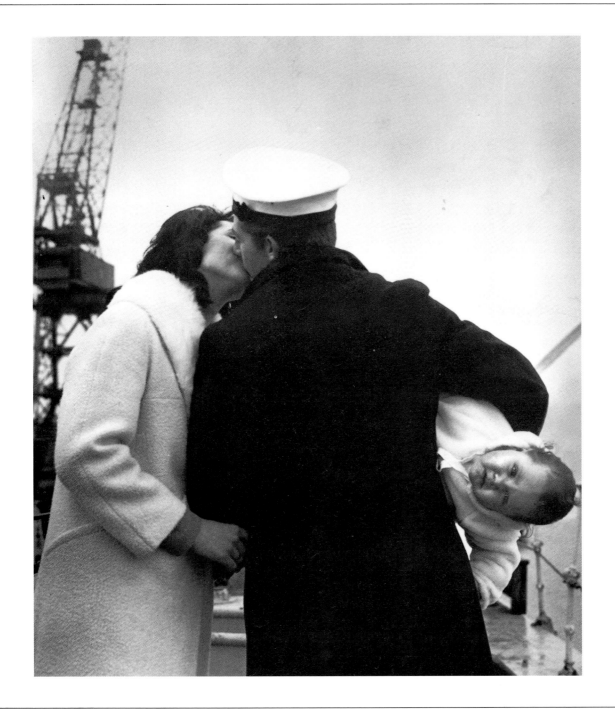

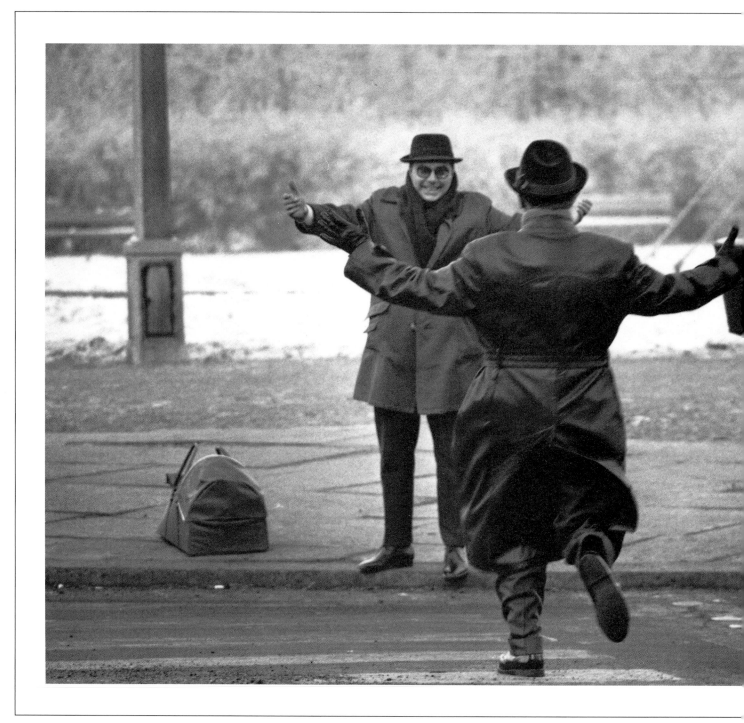

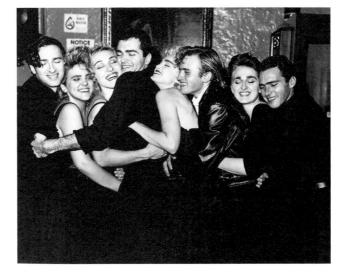

MADONNA AND HER
SIBLINGS
Bruce Weber, 1986

BROTHERS REUNITED AT
THE BERLIN WALL
Ian Berry, 1963

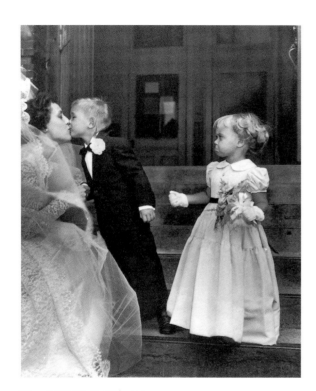

JEALOUS FLOWER GIRL
Mildred Totushek, 1954

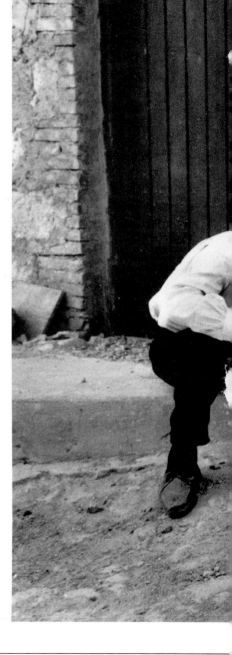

SICILY
Ken Heyman, 1968

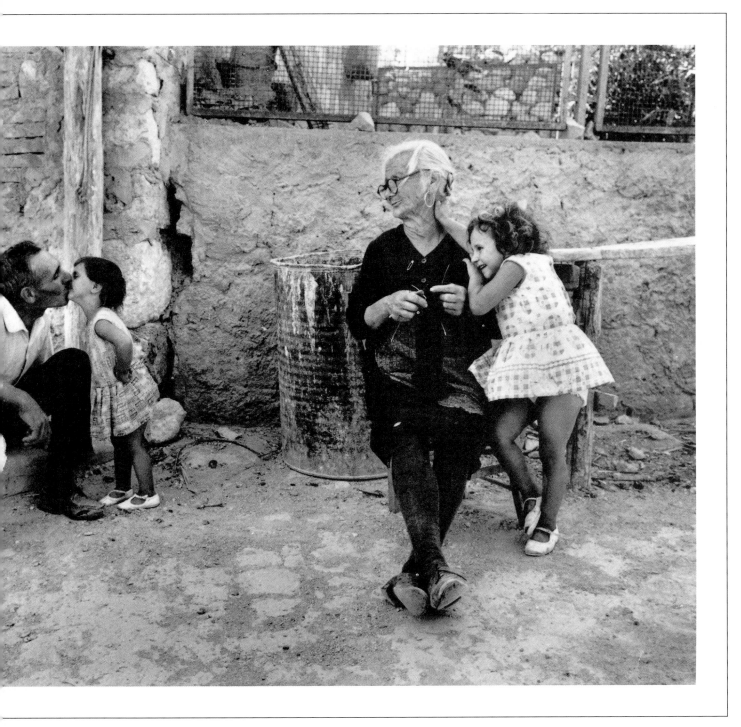

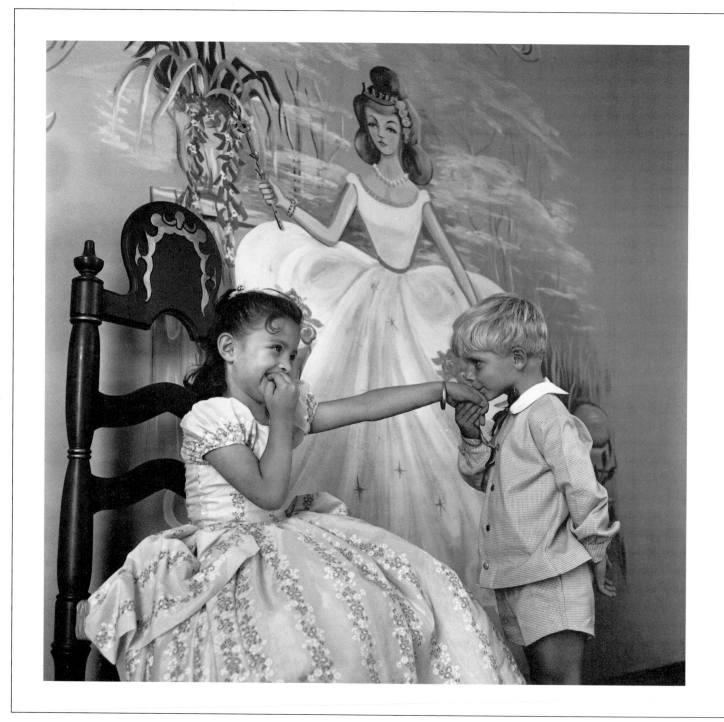

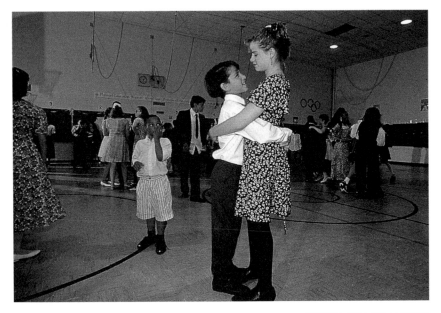

SIXTH-GRADE DANCE
William Snyder, 1994

THE ART OF HAND-KISSING
Antonio Halik, 1964

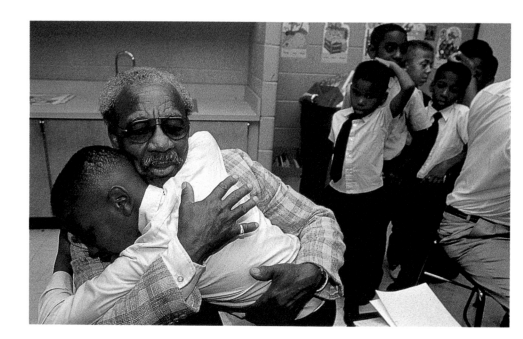

A HUG FOR HOPE
Donna Ferrato, 1991

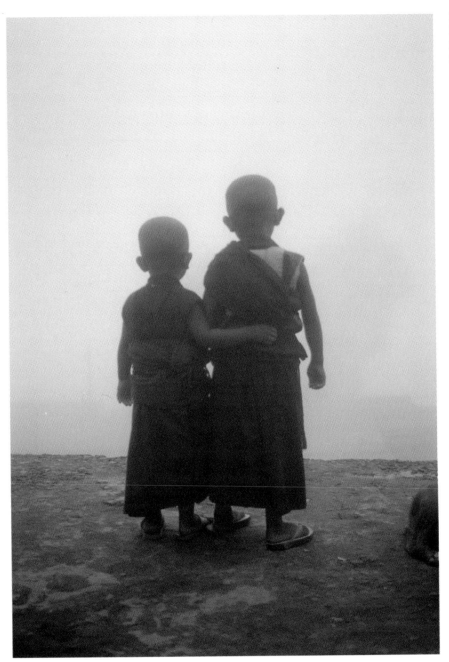

BROTHERS AT A TIBETAN
BUDDHIST MONASTERY
DARJEELING, INDIA
Don Farber, 1989

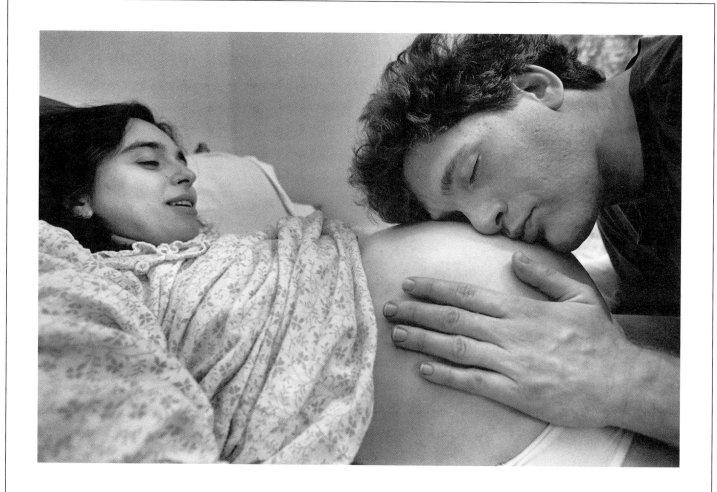

THE BIRTH OF A FAMILY
Eugene Richards, 1990

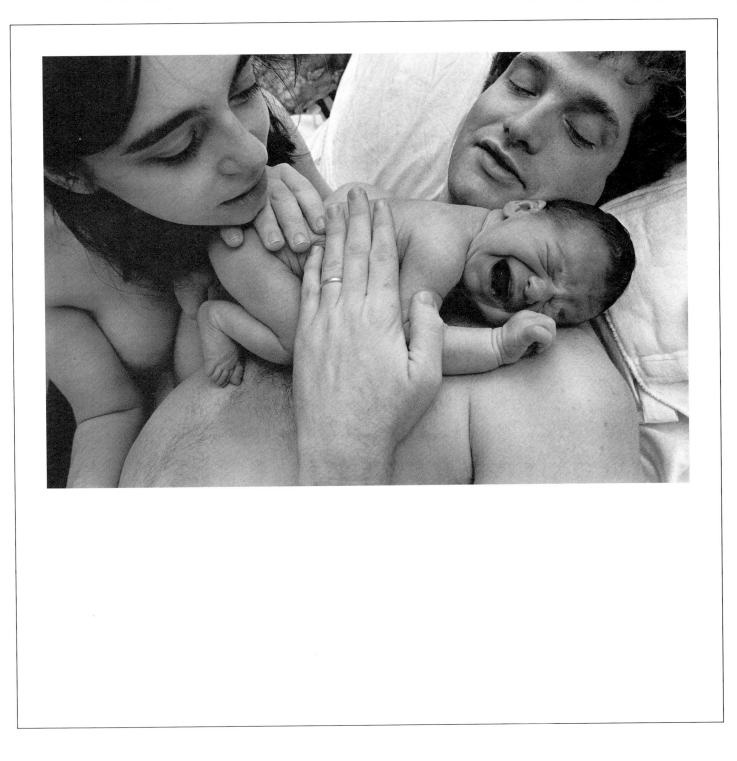

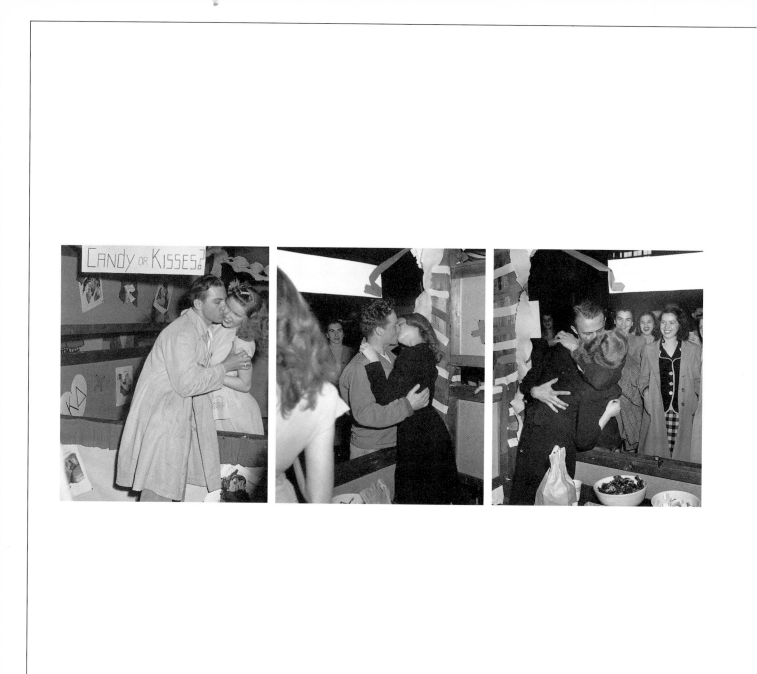

KISSING BOOTH
Frank J. Scherschel, 1946

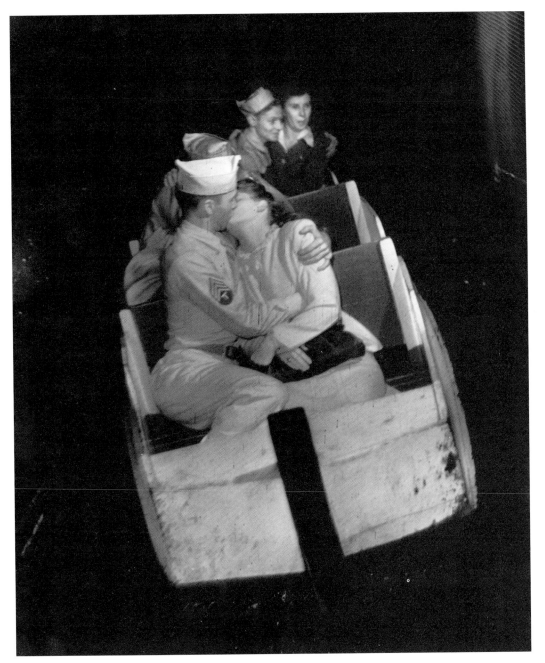

TUNNEL OF LOVE
Marie Hansen, 1946

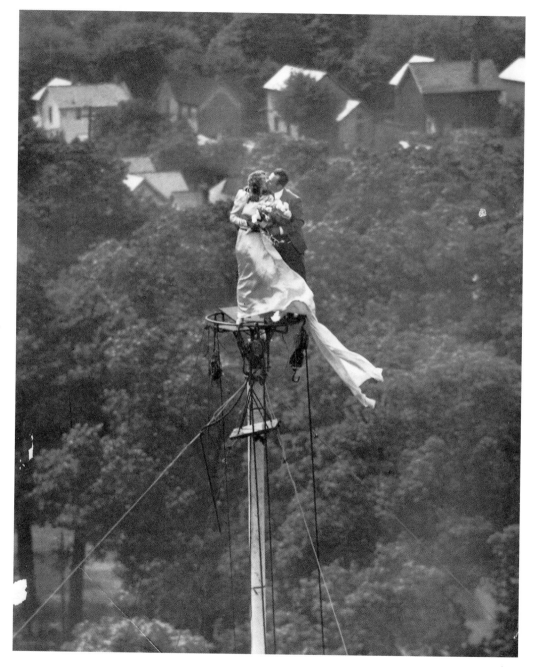

FLAGPOLE WEDDING
Allan Grant, 1946

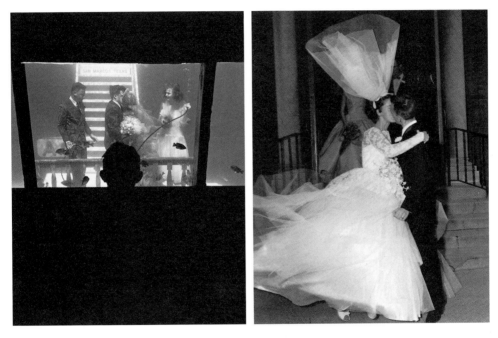

TAKING THE PLUNGE
John Dominis, 1954

BLOWN AWAY
Louis A. French, 1957

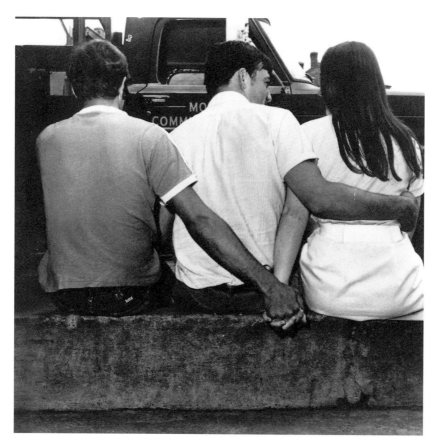

THREE'S COMPANY
Anthony Bruculere, 1968

PORT OF CALL
Central Press, London, 1961

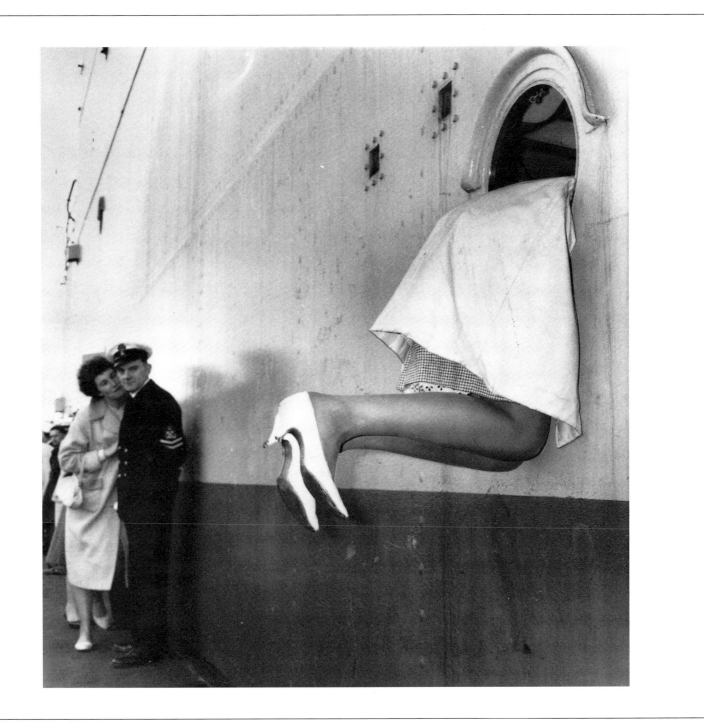

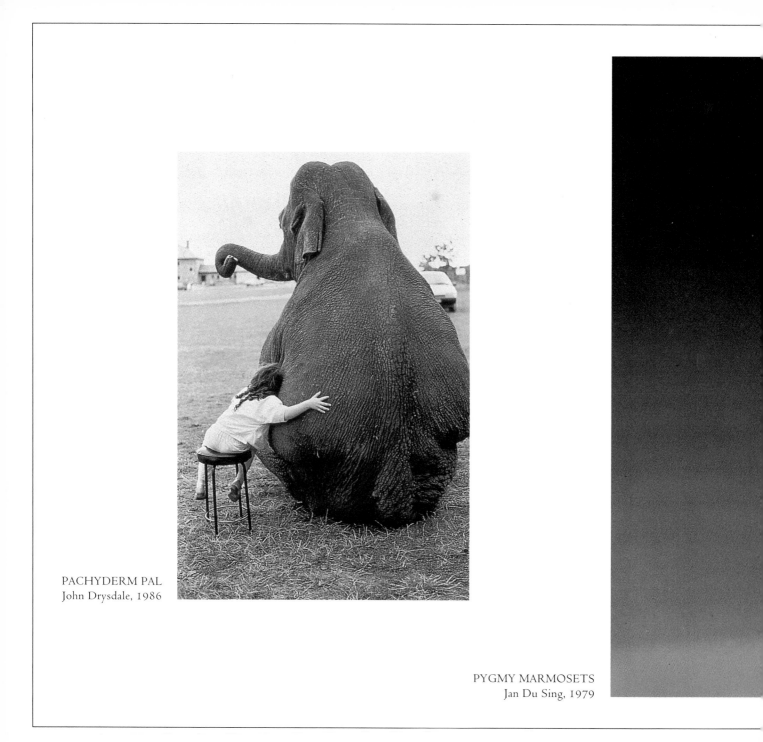

PACHYDERM PAL
John Drysdale, 1986

PYGMY MARMOSETS
Jan Du Sing, 1979

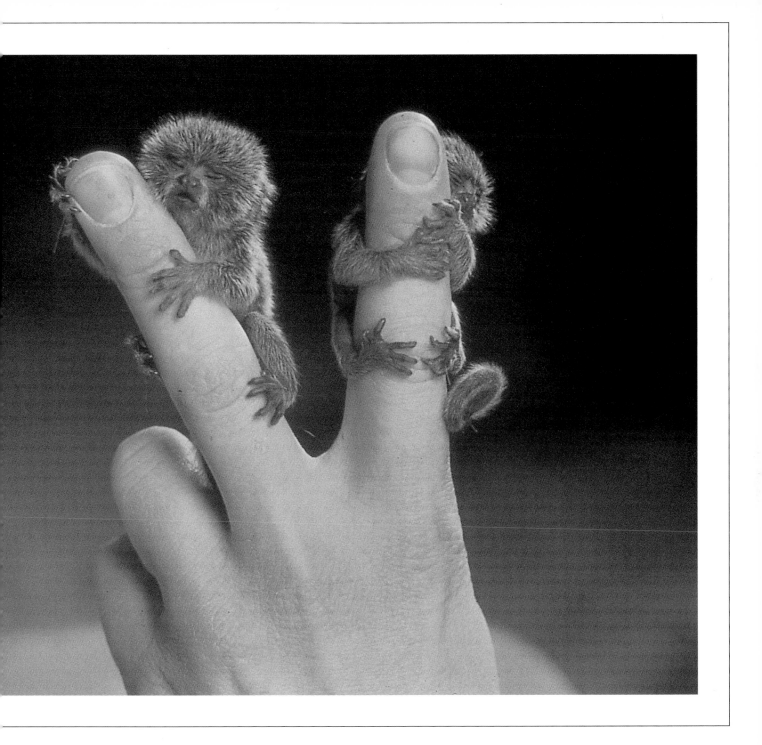

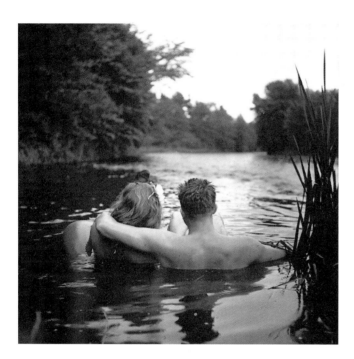

APPLE RIVER, WISCONSIN
Alfred Eisenstaedt, 1941

HAVASU FALLS, ARIZONA
Harald Sund, 1981

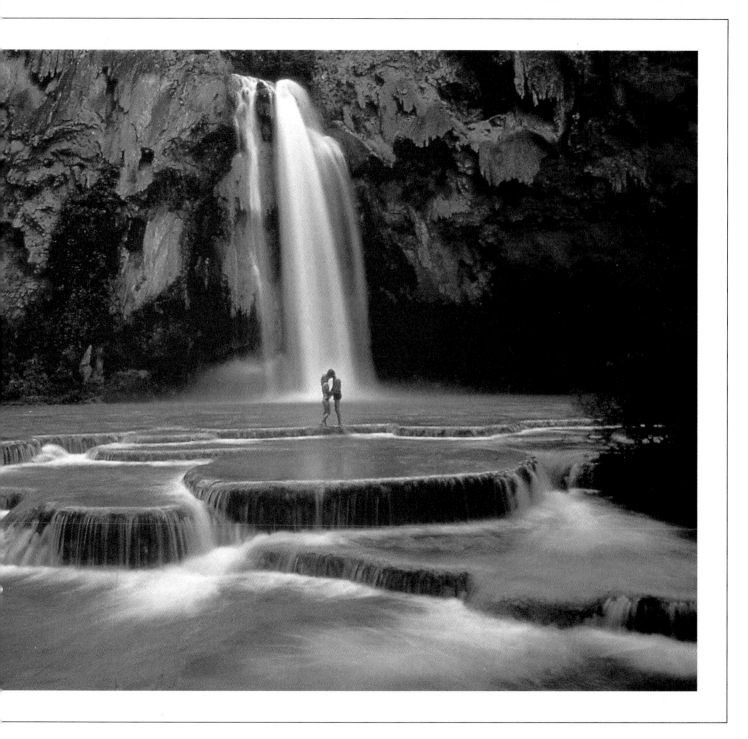

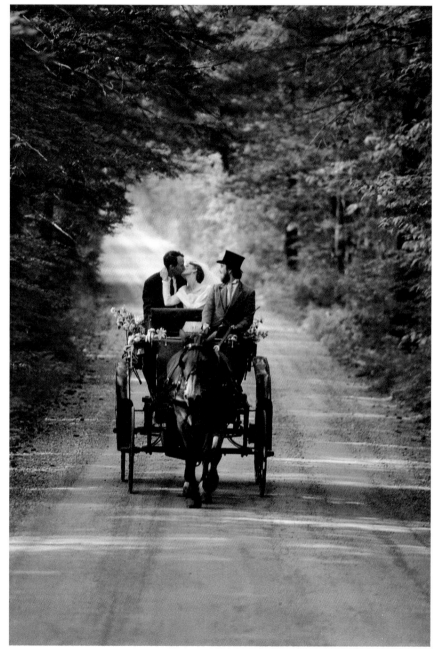

VERMONT WEDDING
Dirck Halstead, 1990

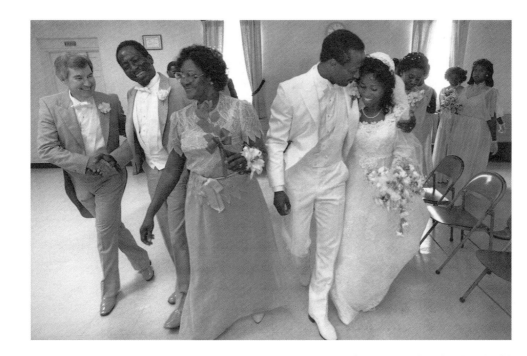

SOUTH CAROLINA WEDDING
Eli Reed, 1984

VIETNAMESE WEDDING
BANQUET
Donna Ferrato, 1994

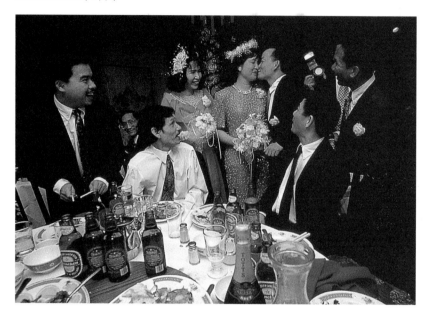

EMBRACING HER HERO
John Loengard, 1985

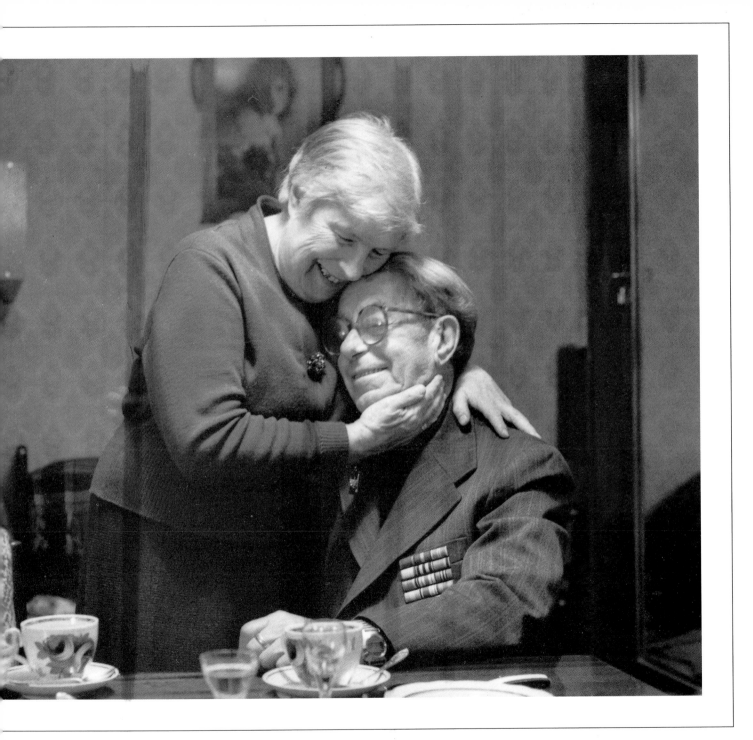

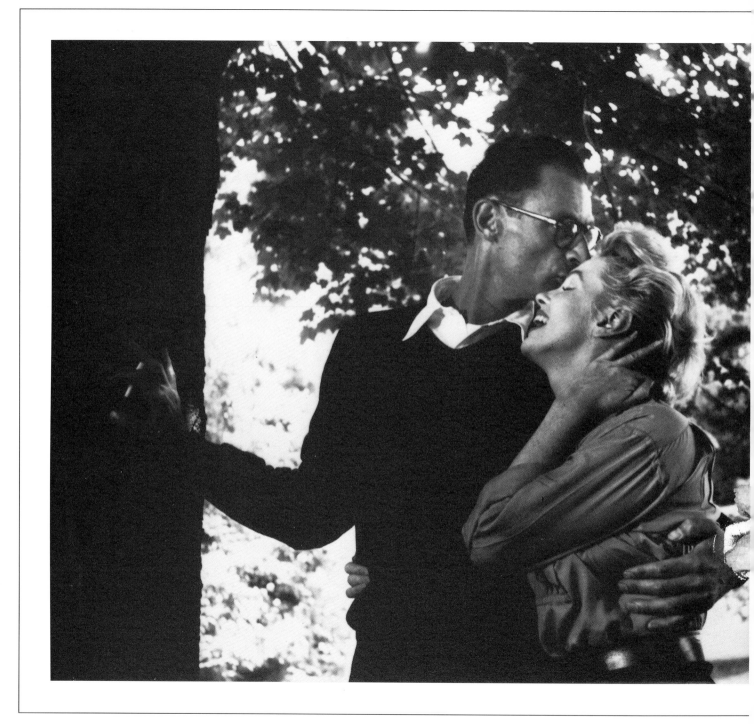

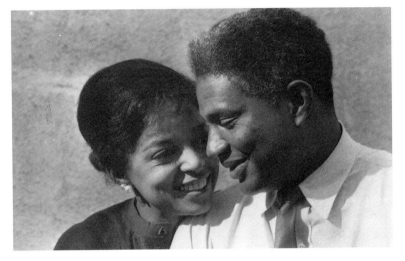

RUBY DEE AND OSSIE DAVIS
Henry Grossman, 1963

ARTHUR MILLER AND
MARILYN MONROE
Ken Heyman, 1956

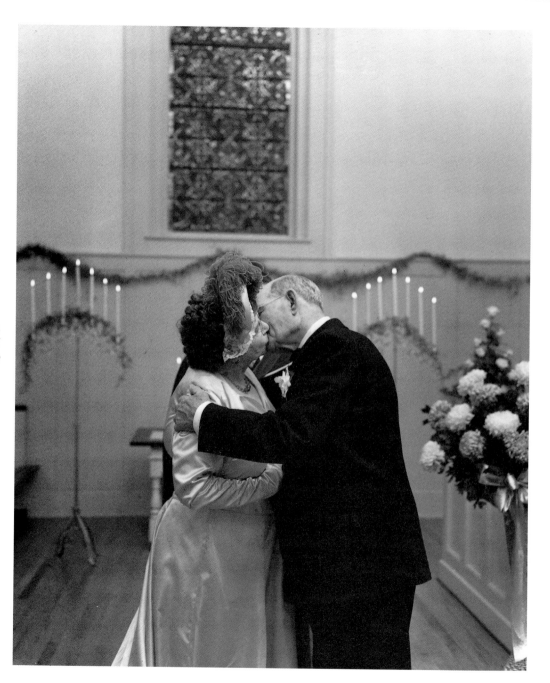

FIFTIETH WEDDING
ANNIVERSARY
A.Y. Owen, 1950

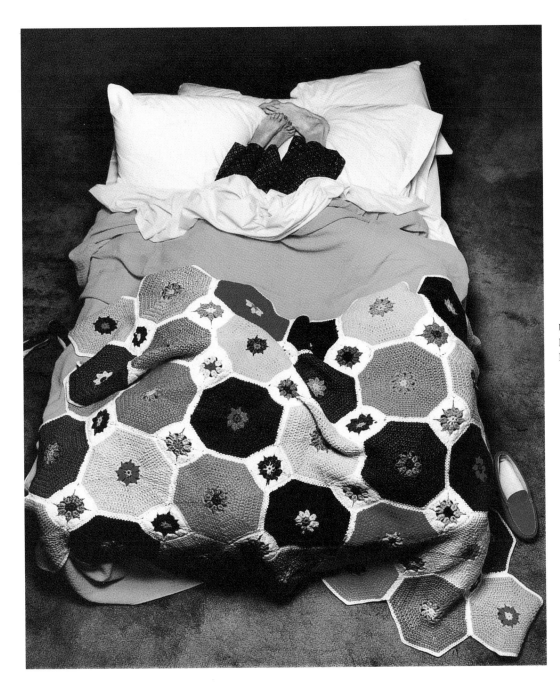

UNDER COVERS
ERMA AND BILL BOMBECK
Peggy Sirota, 1993

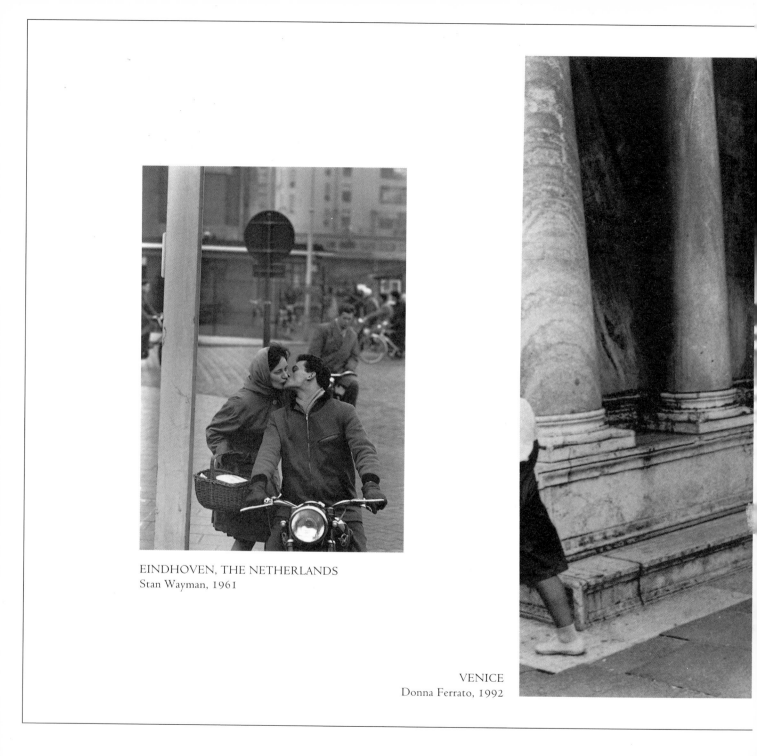

EINDHOVEN, THE NETHERLANDS
Stan Wayman, 1961

VENICE
Donna Ferrato, 1992

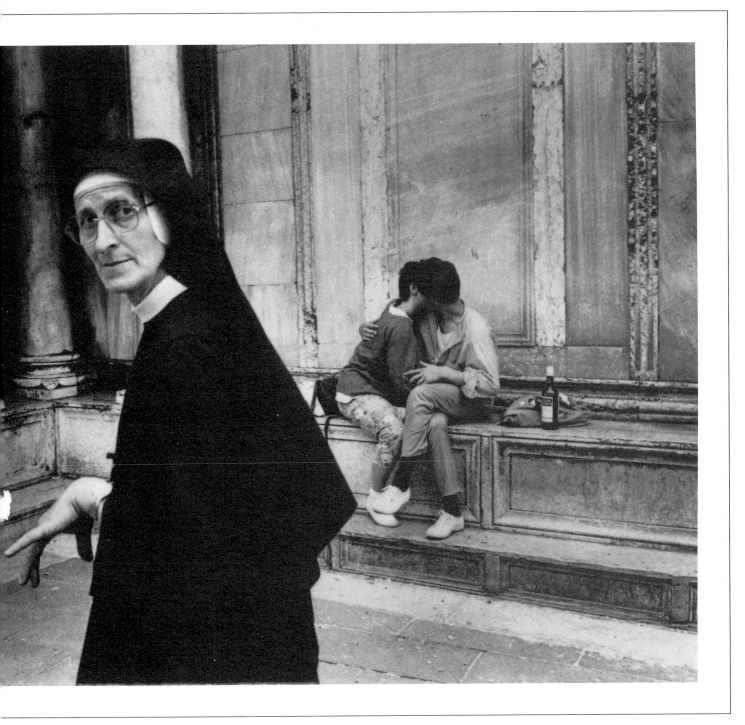

COLLEGE SWEETHEARTS
Bill Ray, 1970

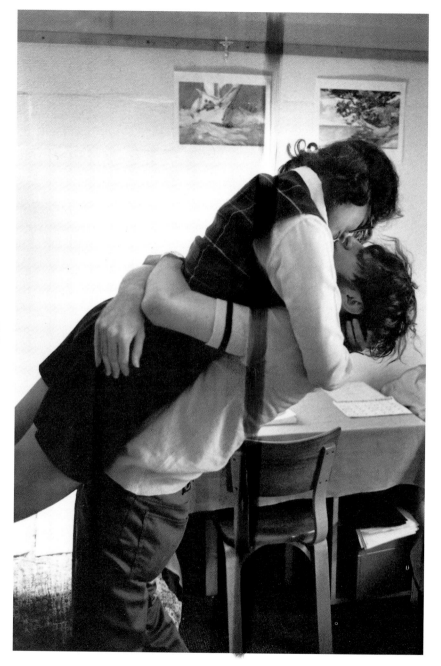

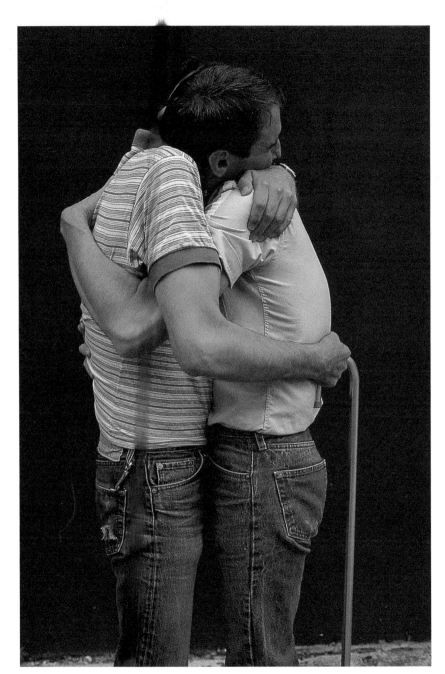

PERSON WITH AIDS BEING
COMFORTED BY A FRIEND
Frank Fournier, 1985

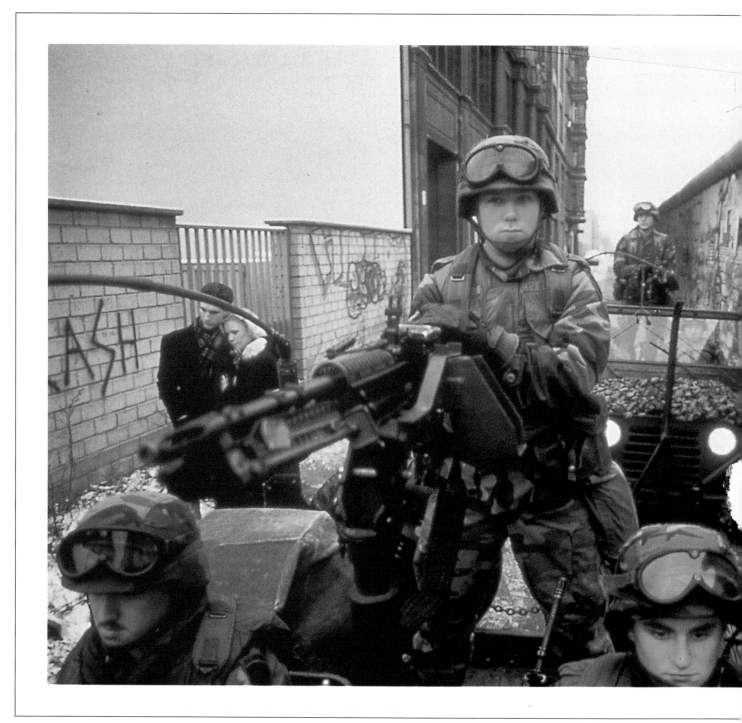

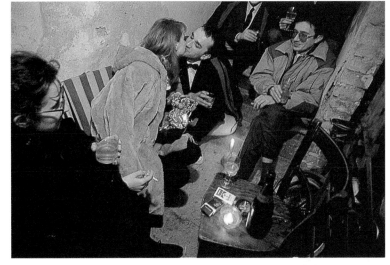

DADA AND BOJAN'S WEDDING
Sarajevo
Tom Haley, 1993

WEST BERLIN
Harry Benson, 1986

NEWLYWEDS
CHIHUAHUA, MEXICO
Larry Towell, 1992

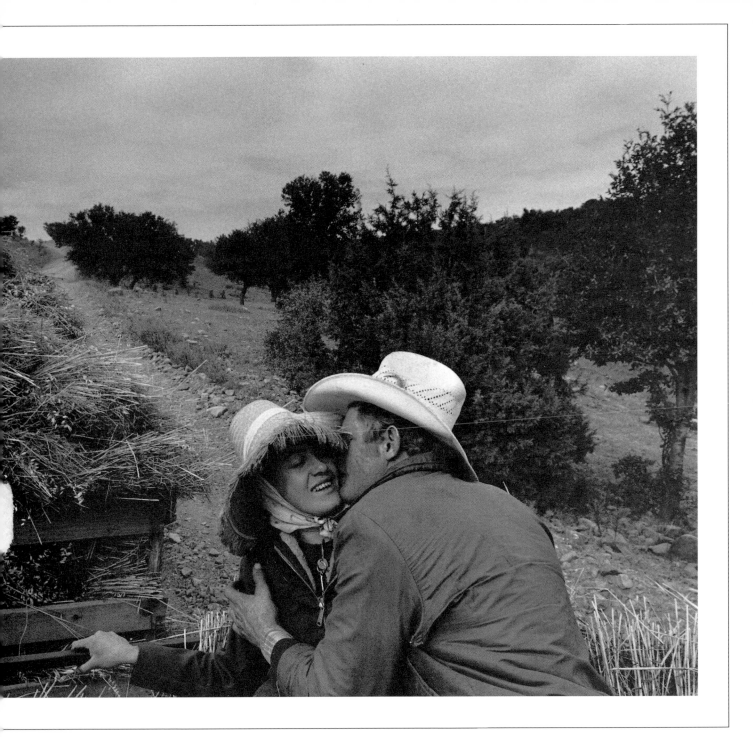

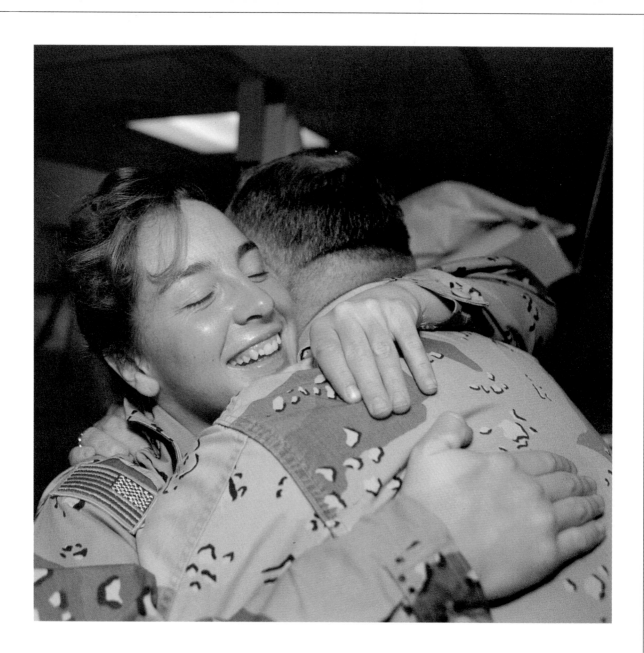

GEN. H. NORMAN SCHWARZKOPF AND
RETURNING P.O.W. MELISSA RATHBUN-NEALY
Harry Benson, 1991

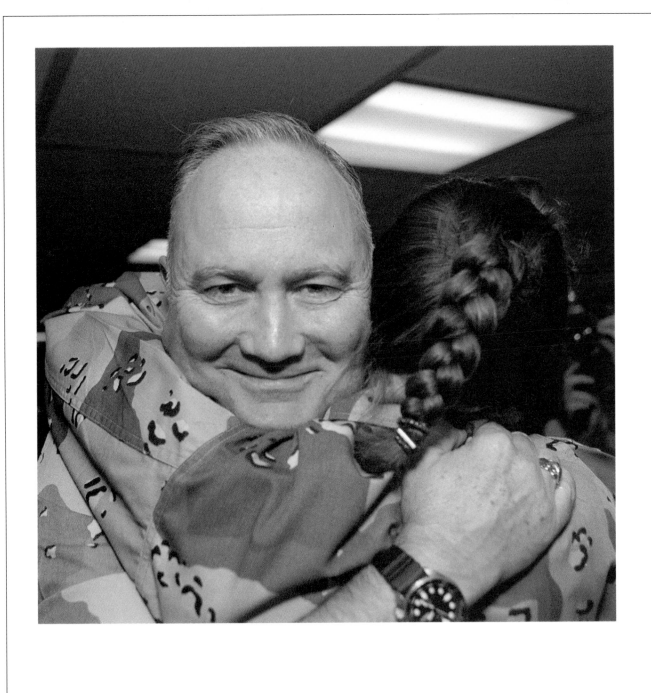

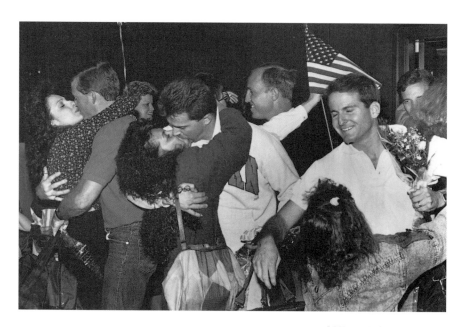

GULF WAR REUNION
Lynn R. Johnson, 1991

HIJACKED PASSENGER
WELCOMED HOME
Dennis Cook, 1985

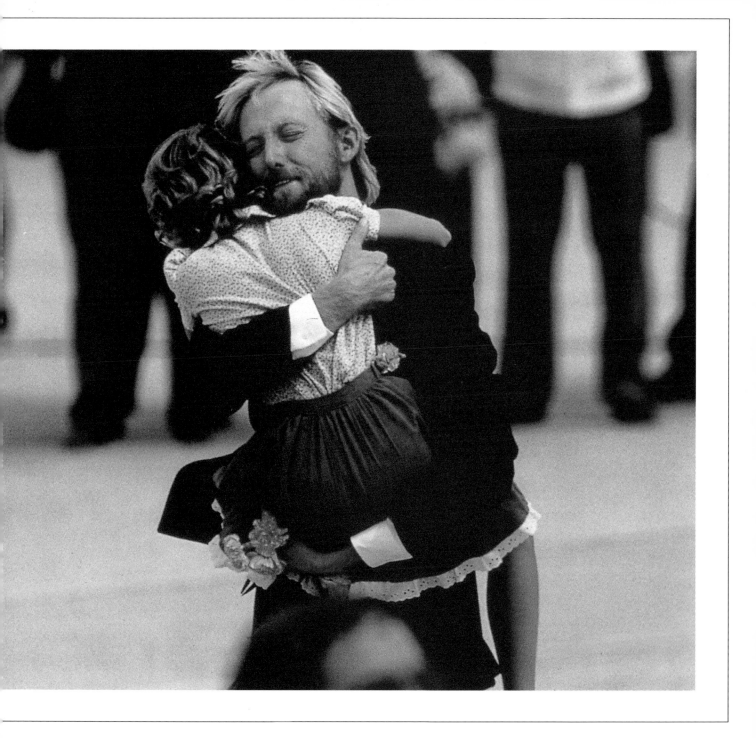

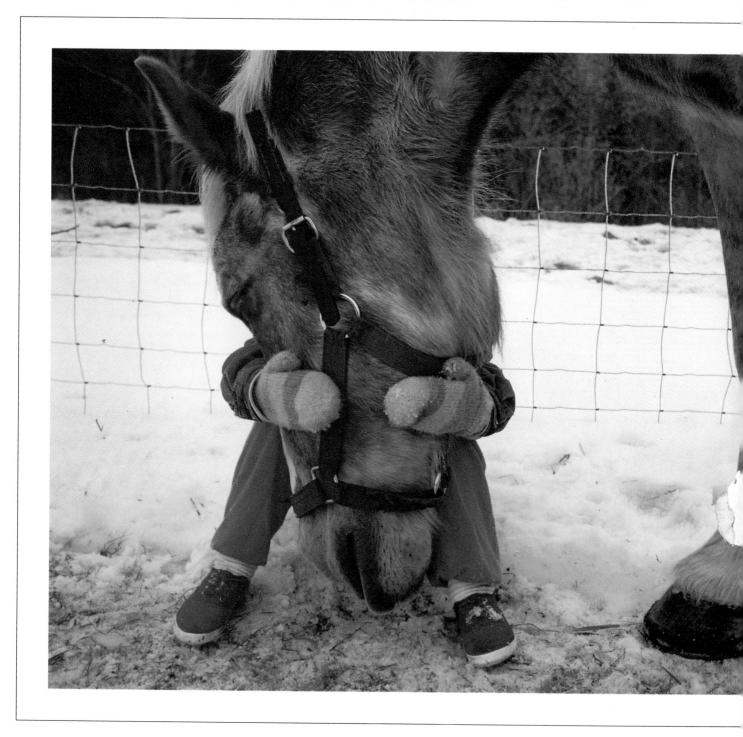

NUZZLING
Joe McNally, 1991

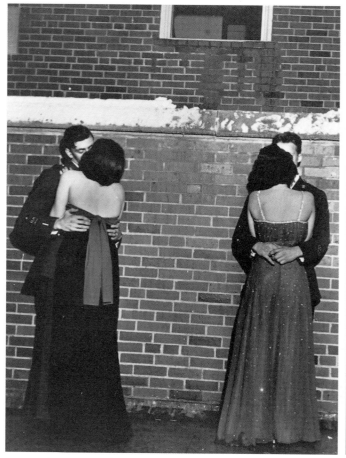

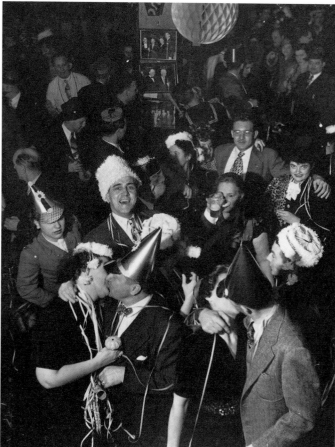

GOOD-NIGHT KISSES
Alfred Eisenstaedt, 1939

NEW YEAR'S EVE
Yale Joel, 1946

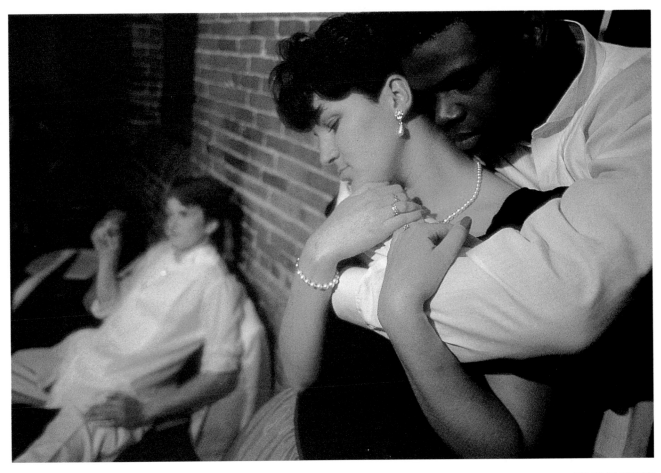

PROM NIGHT
Dan Habib, 1994

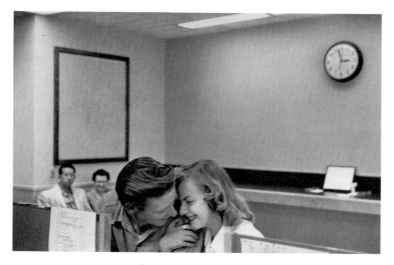

MARRIAGE LICENSE BUREAU
Elliott Erwitt, 1955

MARRIED EIGHTY-ONE YEARS
Philip Jones Griffiths, 1986

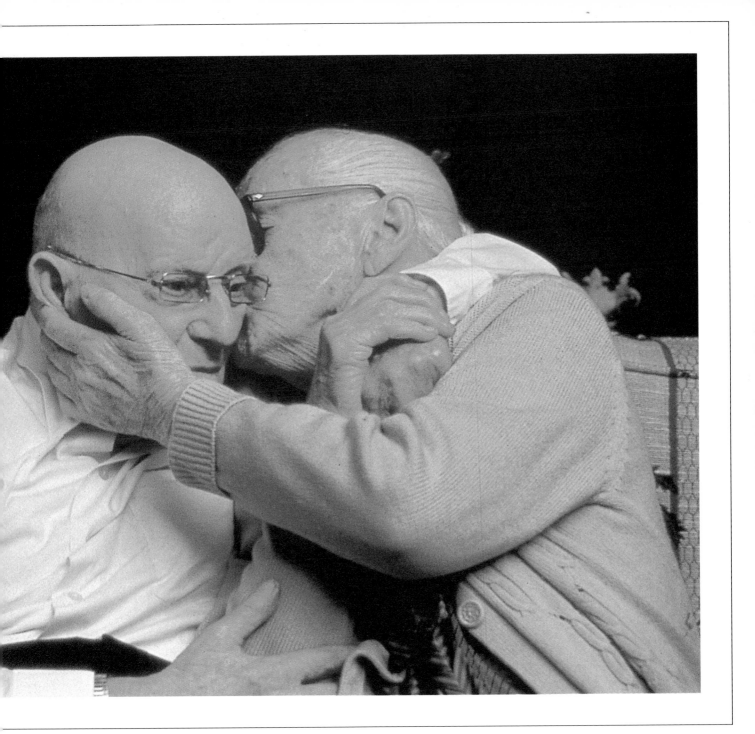

JE T'ADORE
Alfred Eisenstaedt, 1963

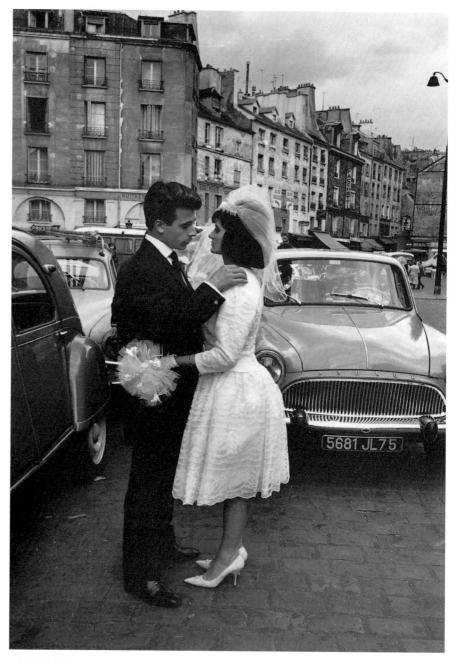

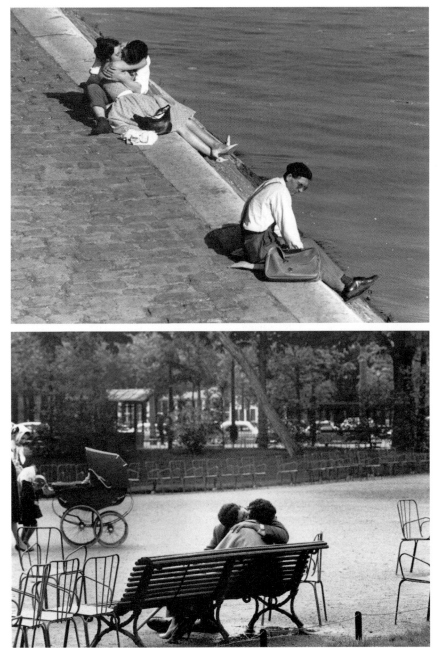

PARIS
Dominique Berretty, 1959

PARIS
Toni Frissell, 1962

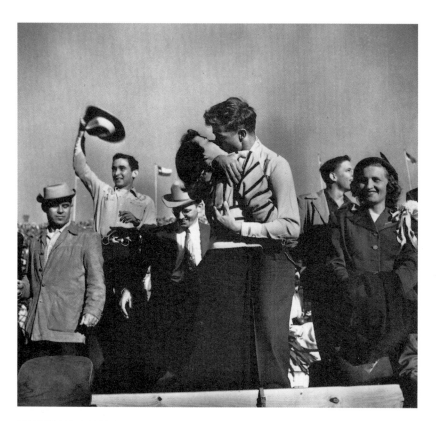

FOOTBALL VICTORY
Joe Scherschel, 1950

DATING
Harry Benson, 1986

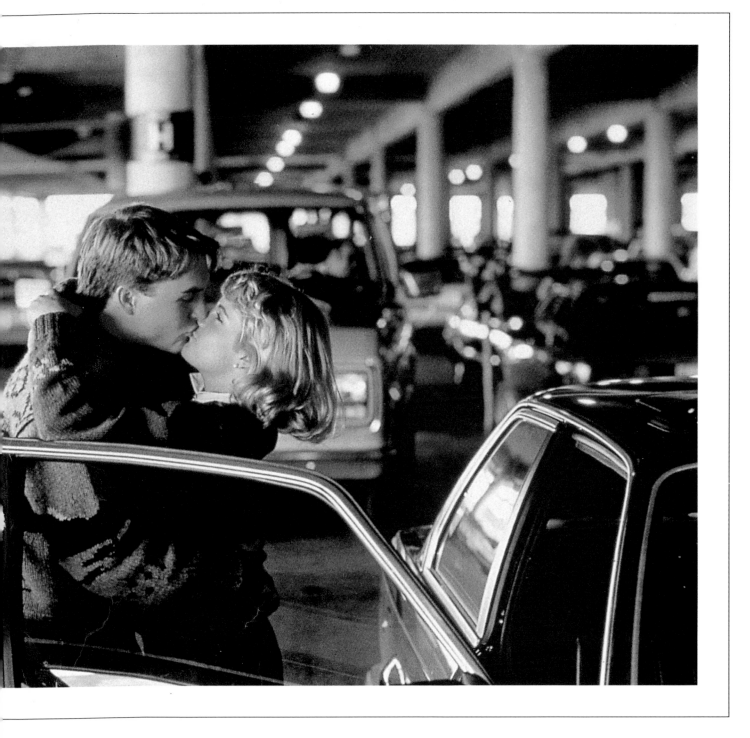

HAND IN HAND
Paul Schutzer, 1963

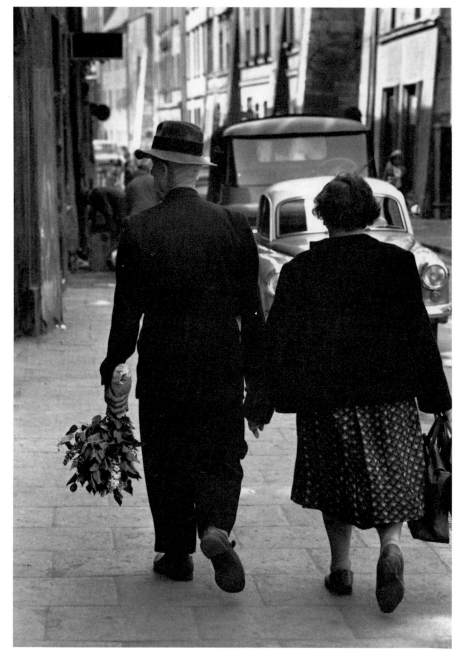